THE AMY AWARD
ANTHOLOGY

THE AMY AWARD
ANTHOLOGY

The Shortlisted Stories of the 2021 International
Amy MacRae Award for Memoir

EDITED BY
ALISON WEARING

TABLE OF CONTENTS

INTRODUCTION

In May 2019, a group of writers met at the Mindful Memoir retreat in southern France. Among them was a sparkling young woman named Amy. I believe I speak for everyone in the group when I say that we all instantly loved her spunk and spirit, her honesty and tender heart.

The writing Amy presented during the retreat was spectacular, and she spoke often of her daughter, then four years old, and her husband Garreth (who, among other things, surprised her with a bouncy castle at their wedding—the photo of Amy and her bridesmaids bouncing in their dresses might be the most beautiful wedding photo I've ever seen). Amy also spoke of her work as a kindergarten teacher, which she adored, and of her cancer, the terminal diagnosis she had been given a year earlier, and how deeply she wanted to write her story, to give life to her voice on the page.

On the last night of the retreat, Amy gave us all glow sticks and we followed her in dancing around the living room of the château to her favourite tunes. It was crazily fun. The next morning, Clara (with whom I facilitate the France retreats) and I took everyone to the train station and we waved like maniacs from the platform as Amy sped away to Paris, where she would catch her flight home to Vancouver.

Over the ensuing months, Amy worked hard revising and polishing one of the pieces she had written in France. "Do you really think it could be published," she asked me at one point, "or are you just being nice?"

I assured her I was being honest, that her writing was strong and pure, simple and majestic, but I'm not sure she ever believed me. The best writers often don't.

On June 1, 2020, at the age of thirty-five, Amy died of ovarian cancer.

A few weeks later, the CBC contacted the writers whose stories had been selected as finalists for their prestigious annual literary awards. Amy MacRae was one of five writers shortlisted for the CBC Nonfiction Prize.

In the ensuing months, I thought of Amy a lot. Sometimes I would 'bring her with me' on hikes, her presence a reminder of how fortunate I was to have a body healthy enough to scale a rock face, skip over tree roots, or just close my eyes and listen to the wind peel a layer of water from the surface of the lake.

Amy taught me to see every grey hair as a privilege, every interaction as an opportunity for kindness, and every morning as an offering, even in the midst of a lockdown.

One afternoon, in the depths of winter, I was snowshoeing through the forest with Amy in my heart, when I had an idea. Or rather, Amy passed me an idea. Or rather, she pressed a thought into the shape of a snowflake, blew it off a high branch and let it spiral down and land on my nose, at which point I smiled and looked up, blinked a few times, and felt as if I had an idea. (Pick your preferred understanding of inspiration.)

The idea was to create a literary contest in Amy's honour and donate the proceeds to her living legacy fund for ovarian cancer research.

Thus, the *International Amy MacRae Award for Memoir* was born. Having never run a literary contest before, I simply drew on my experience of being a reader and judge for other awards. Assuming this would be something of a trial run, I put the word out tentatively, but within a few months, we had 248 submissions. Suddenly, this was a real contest!

To help with the early selection process, I invited twelve 'storysmiths' of different kinds (a poet, a journalist, a novelist, a playwright, a

songwriter, a storyteller, a travel writer and a lyricist, as well as a filmmaker, a director, an actor and an English teacher) to be the contest's 'first readers.' Memoir can take innumerable forms, and it felt important to have the stories read and assessed not just by other memoir writers, but also by people who embody and craft stories in a variety of ways.

Each of the stories submitted to the contest was read blindly (without the author's name visible) by two readers. Any story that received a YES vote from both readers was automatically added to the longlist. Those stories that had received a single YES vote were circulated again to a different set of readers, and stories that earned a second YES vote were added to the longlist.

From a total of 248 submissions, thirty-two stories made the longlist. Those stories were passed to our inaugural judge, the award-winning memoirist Anne Bokma, who had the difficult task of narrowing them down to a shortlist. She chose ten finalists, and it is these stories you now hold in your hand.

When it came time to choosing a winner and a runner-up, we ran into a common quandary: there were two outstanding writers with vastly different styles and strengths, each equally deserving of the top prize, it seemed. There was also a third story that was loved by everyone who read it, that swam around the room, insistently.

Three stories, two prizes. What to do?

We decided on a creative solution and one that honoured an important truth about art: that it is essentially uncompetitive and often unrankable. So, you will notice that there are two co-winners of this inaugural Amy Award and a single runner-up. Far from seeing it a display of indecision, however, think of it as a nod to the wild and determined uniqueness of art.

Lastly, I haven't mentioned that most of our readers were volunteers. Or that every writer who submitted their writing to this contest paid an entry fee of $35. Or that many people who learned about the contest 'donated' an entry fee (without submitting a piece of writing) as a way of supporting this initiative.

But it is vital that I thank all of these people, as well as the entire team of superheroes behind the scenes at *Memoir Writing ink.*, because it is only thanks to their collective generosity that we were able to make a donation of $10,000 to Amy MacRae's Living Legacy Fund, thereby pushing the fund's total over Amy's dream of $100,000.

Thanks to Amy's family, Clara and Caroline Courtauld, and the brilliant artist Khosro Berahmandi, we were also able to award generous prizes to the winning writers and runner-up, and these three writers are set to join me at the next Mindful Memoir retreat in southern France, where all of this began. Special thanks also to Laurie Gough, Deb Gibson, Heidi Sander and Jamie Arts, for helping this book to take shape.

Every piece in this collection is a testament to the power and value of writing our stories.

And I am grateful to Amy, for inspiring us all.

with a hand over my heart,

Alison

COMMON LANGUAGE

BY KARIN JONES, CO-WINNER

They were two upright pillars in the heat-soaked distance. As we got closer, it was clear they were children, a boy and a girl, who looked to be about ten. Dan slowed the Land Cruiser to a halt. It was hard to say who was more surprised, the disoriented travelers crossing paths with a couple of kids in the arid country of northwest Namibia or the desert dwellers themselves, looking both impassive and dazed, as if a bus had arrived on schedule, powered by wings.

The boy wore tight braids plaited forward, resting on either side of his face like the horns of a young wildebeest. A beaded loincloth hung loosely from around his ramrod waist. The girl's skin was tinted umber and her coiled hair caked with coppery dried mud. Around her neck and wrists were rings of woven reeds and leather.

"Do you suppose they're our guardian angels?" I whispered.

My husband had missed the tertiary track to Epupa Falls, opting to follow the faintly dotted line on our African map rather than the road

more traveled. This route had turned out to be not much more than a suggestion. We were lost.

"Epupa Falls?" he asked the kids, waving his hand forward. They gestured back in a perpendicular direction and took off running, motioning for us to follow.

For nearly a mile these children ran over the hard dirt of the upper Kunene River watershed, barefoot and grinning, their legs ghostly with grey dust. They were giddy, looking back at us with open smiles, as though commandeering a three-ton kite that was miraculously still aloft.

When the children slowed to a trot we were alongside a thicket of trees. A half dozen adult versions of our young guides suddenly emerged. Dan stopped the vehicle and turned off the engine. We looked at each other with wide eyes and raised eyebrows, and without a word, just a nod, we opened our doors and slid from the high vinyl seats.

Dan beamed, pointing at the kids. He pressed his palms together and bent slightly at the waist. Then he turned to the adults. "Epupa Falls?" he said, holding out his hand and twisting like a weathervane. To our astonishment a tall man, wearing composure like a mantle, replied in English.

"That way," he said, pointing north toward the more established road I had suggested earlier, which Dan had dismissed. I often went with Dan's sense of direction even when it butted against my own. He was generally the more reliable navigator, guiding us through dozens of countries over as many years together. He melded safety and adventure like a well shuffled deck of cards.

Women moved toward me and a few tapped the pads of their fingers to their lips. I walked to the back of the vehicle, opened the heavy swinging door with our spare tire attached and pulled out the crate filled with non-perishable goods. I offered our flour, salt, rice and

canola oil. The women took them with quiet grace, as though this was a routine sub-Saharan Amazon delivery. Then, a diminutive elder moved in for a closer inspection. She was draped in worn cotton with a faded geometric print. The skin of her arms and face hung from her body like an additional layer of material.

She spoke at me sharply while peering into the deeper spaces of our rig, moving her palms from side to side as if to say, *that's all you got?* Dan and the English speaker came around to check out the commotion. I nodded toward the old woman and addressed the man.

"What is she saying?" I asked, hoping she hadn't spotted my M&M's. Maybe she was demanding we give up our tools, spare parts or clothing. The man looked past the plastic bins then turned to Dan.

"Where are your children?"

Children? I looked at their faces, all veiled with a genuine look of confusion. We were a couple after all, still young, married by evidence of the rings on our fingers, and rich enough to afford this palatial home on wheels. It was a fair question.

Dan answered apologetically. "We don't have children." His feigned remorse was so convincing I just about grabbed a can of corn to hurl at him. If it broke open his chest, what would spill out? Imagined calamities? Yowling fears? The songs of his absent father?

"No," I said, addressing the woman and shaking my lowered head. "No children."

The man spoke a few words to the old woman and jerked his head to the side, a gesture that looked to me like pity. Heat rose behind my eyes as I heaved the crate back into place and slammed the door. They all took a step back.

But the old woman was not done with me. She clapped her bony hands together and launched into an incantation, a cross between an ululation

and a prayer. Then she dropped to her knees at my feet. Still chanting, she slipped a spiral of bronze metal from her tiny wrist and pressed it into my hand. I looked at her, confused. She used my other hand to rise back to her feet then pushed the bracelet to my chest. I shook my head and smiled, trying to say, *this isn't necessary*. But she shoved a little harder, held her rawboned fingers against mine so we were gripping the bracelet together. She had astonishing strength, coming from somewhere other than those withered muscles. I looked into her rheumy eyes, cloudy with cataracts, and understood: *This will bring you children. Your children are missing and you need to find them and lead them into the world.*

She backed off and stood solemnly, arms at her sides, her head bobbing towards the ground. I squeezed the bracelet, feeling as though it were magnetic and all the metal filings of my regrets were vibrating up from the place where I'd stuffed them.

Dan and I got back into the Cruiser, and everyone gathered in front, watching us through the windshield. There was a barrier thicker than glass separating us now. Yet they waved kindly and we waved back. I held the warm talisman cupped in my lap as we drove towards our corrected direction, rehearsing what I would say to Dan that night, my heart rate ratcheting up each time I imagined uttering the words: *We need to have a baby.*

* * *

We bush-camped that night, still a slow day's drive away from the falls. Setting out the folding chairs, I felt an avoidant urge to be back home in Seattle, at work in the Emergency Department, never slowing down long enough to think. In the desert, buried dreams demand an excavation.

Dan raised the rooftop tent while I made dinner, helping myself to an extra glass of wine from our three-litre box. After BBC Africa on the

transistor radio, we sat quietly as the sky edged toward dusk.

"I was thinking about two nights at the falls before heading to the coast," said Dan. We had eight more days in Namibia. I did not reply. "You ok with that?" I could hear the concern in his voice, his knowing sense that I was churning over something less logistical. I spoke while keeping my eyes on the horizon.

"I will never feel like I belong in this world until I have a child, Dan."

In my peripheral vision I could see his head shaking before he even replied. He would be unmoved again, insisting, as he had several years earlier, that kids were out of the question, that if I really wanted them, I would need to find someone else to have them with.

"We've had this discussion. You know how I feel."

"They felt sorry for us. *I* feel sorry for us!" I snapped.

"It doesn't matter how they felt. This is our choice," he said, as though he was the only driver and it was impossible to turn this childless vehicle around.

A heaving welled up, pitching me forward. I ran with it, literally, away from Dan, over the metamorphic rock. I ran until I was out of sight of our camp. I stopped at the edge of an escarpment overlooking the deep gold and grey mass of the Namib desert and crumpled onto the warm ground.

The twilight was so clear and sharp that each faint star, even before the light had left the day, was coming into a binocular focus. I slipped off the wedding band we had designed together nine years earlier and rolled it around in my palm. A fat black beetle trundled across the ground. I imagined myself small and insect-like and wondered what I might be crawling toward, whether a bug's life had some internal compass I was missing. Then I busted myself out of that carapace and grew to the roof of the sky where my head was cold and my feet

hot. When I looked down from my soaring height, I could see all the lands and all the tiny cultures of the world revolving around their own joyful, agonizing families. Then I wrapped my arms around the earth like a mother.

I left my wedding ring in the dirt. When I got back to camp, I told Dan what I had done. He put on his headlamp and went looking for it.

* * *

We returned to Namibia a few years later to arrange for the shipment of the Land Cruiser to the U.S. It represented the ending of many things: our travels through Africa; our abandoned hope to drive to the Middle East; our life as a couple who traveled alone through poorly mapped countries. But before we had the vehicle crated and put on a boat, we returned once more to the Namib Desert. Dan would build a fire after dinner, I would lay down a canvas tarp next to it and place a cold beer in the cup holders of our camp chairs. Then I'd set our son in the center of the tarp.

For a magic window of time, our child was a perfect travel companion. He was content to sit but not yet crawl, his cheeks still fat from nursing and gumming the puréed yams and peas I'd spent weeks dehydrating at home. When in towns, each time we entered a restaurant, women would swarm and scoop up our baby. They would cradle him against their hips and sway and sing their mother songs. He would laugh and throw back his head. When food arrived, he was whisked away so we could enjoy our meal unburdened. After dinner, we'd find him in the kitchen, squealing with the attentions of more women and their own children. In campgrounds, kids would pitch up to our site to play dusty patty cake. I pulled out party-sized bottles of bubbles and we watched tiny transparent balloons rise up among the camelthorn trees.

We continued to travel the small tracks, taking along a beefed-up medical kit and one additional evacuation insurance policy. Dan still navigated. What had broken out of him was a recalibrated definition of adventure; parenthood as an unexplored country. And without speaking a word, we became fluent in the language I thought we'd never speak.

The copper bracelet traveled in the glove box. It crossed the Atlantic and passed through the Suez Canal. It made its way up the North Pacific and now nests inside a basket woven of desert grass, smelling of salt bodies and earth. The old woman lives there still, in the scent of it, her song echoing a long line of mothers who have kept the fabric of humanity intact. I will pass it on some day to the next woman who needs it.

CALL ME LATER

BY HILARY FAIR, CO-WINNER

What were the signals?

1. Your tanned skin and the fine, tight muscles of your biceps hang free in a white tank top though it is December. A foam lemon is tied to a string, which is tied like a choker around your neck. The tortilla chips on the counter are thick and round, ploughed in the salt we will need to absorb the Southern Comfort and Peach Schnapps in our bellies. This is a house party, one of my first—and my first time meeting you. Destiny's Child is on the charts this year, but you and me? We will talk about Bob Marley, the music of my childhood, and in the months to come we will dance to his voice, too. You are the only other young person I know who knows who Haile Selassie is. You have left this small town of ours and though you have come home with your braces still on, you have also returned

fluent in Portuguese. You're worldly, I mean—unconventional and very strange and thus, so beautiful. Of course, I love you. Immediately, profoundly.

2. You take me skiing through the winter fields near your home. Near the woods where, I will later learn, you once hung by one arm from a tall pine's branch and considered letting go. In retrospect, I will see it: your mind—a philosopher king's; your heart— weighted by arrows and anvils.

3. Pizza Hut, in the days of dessert pizza and ice cream buffets. I am lactose intolerant, and you are telling me that you are leaving me to become a monk. You suggest, repeatedly, that I take solace in the idea that I am the last girl you will ever love. You explain that you will still go to your first year of university, to study languages and Asian philosophy. It's the pre-med sciences, a course of study that was pre-ordained for you, that you won't do. We have a year. We can date until you leave.

4. Two teens by the river. Leaves still green, sun high. Me, missing you. Imagining you on a limestone campus, meeting new people and learning Japanese. Our friend, also missing you, is also stuck in high school for one more year like me. He holds out his cigarette to a duck who plucks the stub from his fingers like a piece of bread and lets it dangle from its beak. It is, briefly, so funny, like a caricature—those paintings of dogs playing poker, cigars in their mouths. When I realize the duck is panicking, veering this way and that, the cigarette stuck in its beak, the whole thing becomes horribly sad. The memory (like most of my memories from this year), will be like looking through a tunnel: time both suspended and in fast-forward, fuzzy at the edges, with the

duck in the centre of it all, frantic and spiraling. Well into my twenties, I will carry the vague wondering if this is, in essence, what life is: an endless circling, breathing in small mouthfuls of smoke.

5. Twin towers down.

6. Your heavy desktop computer is assembled in your family's living room, and I sit there—with your parents and your sister—staring at its bubble-head screen. Three days after what we will begin to call 9/11, you are home from school with all of your belongings in tow. You're asking us to watch *American Beauty*. To wriggle through two hours and two minutes of Kevin Spacey and all that sex, and the profound discomfort of watching it together. After, you take a twenty-dollar bill from your wallet and begin waving it at us, demanding that we consider its ontology. Your hands shake as you interrogate us—about our passively absorbed assumptions about reality; about our phenomenological experiences of the bill and what is happening right now. Your father engages. Your tone grows taunting. You are what my mother will call me a year later: an obnoxious first-year university student. But also, more.

7. A near miss. You don't see the stop sign in the twilight. For days, I have been a little bit frightened, while you are a little bit hyper. I point at the sign; perhaps I grab your arm or yell, *Watch out!* You hit the brake, and when the car to our left crosses the four-way intersection in front of us we see that it is a police cruiser. You give me a high five and I am, briefly, elated—I'm on your team. Today, you know I'm on your side.

8. One of my mother's roses dropped, ceremoniously, into the collection plate. You are climbing, uninvited, into the pulpit to address the church. You asked to go. You, of Buddhist curiosities; of science and reason and mind. Beside you at the lectern, Father John is cherry-cheeked and kind—a Newfoundlander with a voice like a lullaby who puts an arm around your shoulder and lets you have your say. About what? I can't recall—atheism, agnosticism, the *Tao Te Ching*? What do I remember? Me, mortified and weeping in the pew where you left me, while an elderly woman sitting nearby gently touches my back. You glance down at me: *I'm sorry*, you say.

9. You hand-paint a For Sale sign and stake it into your parents' lawn while they are out. The canned goods in their cupboards are now organized alphabetically. You are making another point. About attachment. About false constructs of order. About the holes it is possible to poke in capitalist principles. The absurdity of it all.

10. Talk of plane tickets. Of Jamaica and Bob Marley, and your plans to leave tomorrow.

What were the results?

1. A history of drugs I have pretended not to notice, coming to bear. Your caffeine pills. The ephedrine. Weed.

2. A dozen roses arrive at my parents' front door, attached to a dozen nonsensical notes that I won't remember beyond their gist—you are breaking up with me. I told your parents about the drugs, and you cannot trust me anymore.

3. 2-South, what they call the psych ward of our local hospital. Fluorescent lighting. Heavy steel doors with heavy locks. You have a goose egg on your forehead. Green and yellow bruising with blue-black spider veins threading through it. Your hospital gown is on inside-out and backwards.

4. On my side of that heavy door, I learn that cataclysmic events—9/11, hurricanes, the ice storm of 1998—can trigger things like this: manic episodes; psychotic breaks. So can too much caffeine, ephedrine, weed. A family friend, who is a psychiatric nurse and bi-polar himself, with a rock star history of his own, tells my parents to protect me from you. I have seen this friend stomping around in leather fringed vests, bare-chested in winter; I have heard the stories of dumpster diving and stealing Cadillacs and getting stabbed. He says that you will tear me to shreds, and you do.

5. On your side of the door: a love affair blooming with another patient in your ward. She has a shaved head. You want me to shave my head, too. You tell me that you find this girl *very sexy*. You are wearing the T-shirt she wrote a suicide note on before she swallowed a bottle of pills and took a blade to her wrist. *Get rid of all that puffy hair*, you say to me. *It's the least you could do.*

6. A cinnamon candle burns in the kitchen. My mother takes me to buy apples and ginger cookies from a Mennonite market forty-five minutes north and east. She is plying me with the medicinal effects of what she calls *a change of scene*. I skip school repeatedly because my heart, broken and scattering like papaya seeds—literally, skittering down the stairs of the English department with the rest of my clumsy body—cannot hold more. It's a time when the words *mental health* are welcome in the mouths of no one. I am learning that words like *crazy* and *insane* are pejorative because now they sting me as well. Like the sounds of my friends' voices, crowded around our lockers and talking of blow jobs and sex—things you and I should be doing, too.

7. You have never been attracted to me anyway, you say. You prefer a swimmer's build. I binge. I purge. Try to tame my body into something that will better match your tastes.

8. I visit you while you sit at a large wooden table scrawling geometric shapes. You look dopey. Your mother warned me that you would. You holler at another patient who protests the reggae you have put on the stereo and I watch you sway to Bob Marley's voice, lazy-eyed and sedated, your hospital gown swirling.

9. My dad brings me home a copy of Joni Mitchell's *Blue*.

10. Lifelines: a payphone in your ward and the cordless in my parents' home. I can see the hospital lights from the kitchen when I talk to you. You are one block away. You are on another planet. These phones are the thread of connection through which you give instructions about my hair and tell me about that girl. Say things like, *I'm in here like a caged animal because*

of you, and then tell me that you love me. The last time I call that payphone, a woman picks up and goes to look for you. When she returns, she says you are naked and painting on the walls. You will call me later.

THE PARKING LOT

BY GAIL PURDY, RUNNER-UP

Another COVID outbreak. The entire seniors' complex is locked down again. Only essential visitors are now allowed into the long-term care facility where my mother has been living since January. According to facility guidelines, I am not considered essential.

It is now the middle of November, and today, there are no in-person visits, no window visits, and no FaceTime visits. I cannot remember how many times the facility has closed and reopened during these past months. I am feeling a sense of urgency. My mother doesn't understand why I am not coming to see her. Something is gnawing at my insides. I want to see my mother.

How long will I have to wait this time before the facility opens again? Conflicting thoughts compete for my attention. Will my mother die before I am allowed to see her or, if I do see her again, will she remember who I am? Eight months have passed since her ninety-fifth birthday, the last time I touched her, the last time I gave her a hug.

An idea begins to form. What if I can get her to come to the window? Maybe we could have a long-distance visit between her window and the parking lot. A five-minute drive brings me to the parking lot of the care home. I get out of the car and take a deep breath before looking up to locate the window of Mom's room. She is on the eighth floor, the highest floor of the building. You can see the ocean from this window. She doesn't think to look out the window. She doesn't see the orange and yellow streaks of light weaving through the clouds as the sun begins to set.

Pulling out my cell phone, I press speed dial. Emotions tear at my insides as they always do just before I hear her voice on the phone. "I have not abandoned you," I say to myself as I wait for her to answer the phone. I need to see her. Fear and sadness readily surface these days when I think about my mother. Questions race through my mind. Is she remembering being abandoned as a child? Does she relive the moment she was left in the orphanage when her mother could no longer take care of her? Was she pulled away from her mother's embrace? Is she wondering why I have left her in this place? I continue to ask myself these questions over and over and over again.

"Hello," she says.

"How are you?" I ask, speaking loudly into the phone. "I have been thinking about you."

"Who's this?" she asks.

"It's Gail, your daughter."

"It doesn't sound like you. I didn't recognize your voice," she responds.

I am struggling to accept the journeys I know we are both on. For her, it's the journey of dementia taking all her memories, and for me, the journey of losing my mother. Losing a mother who I am desperate to connect with before she is gone. I have no childhood memories

of hugs or closeness with my mother. I still feel like a child, longing to be the centre of her attention. The last few years have been filled with arguments and misunderstandings, with words spoken out of frustration that cannot be taken back. Each of us expected more from the other than we were able to give. I am longing for something, but I am not sure what it is. Maybe I just want to feel a connection with her before she is gone.

A different relationship has begun to develop during these past months, different from a mother and daughter closeness that develops over time. Past conflicts are beginning to fade and are being replaced with only present moments. This new relationship is born out of my transition from being a caregiver to being a daughter. No longer having to attend to my mother's daily needs, I am able to just be with her. I feel a softening inside me as I realize there is not much time left for my mother, for us. I can feel the heaviness of grief as it searches for places to settle in my body. Compassion has already begun to grow for the little girl who still lives inside me, and also, for the little girl who still lives inside my mother.

We share the usual back and forth conversation as I give the same answers to her repeated question of "What's new?"

"Go to the window," I tell her. "I am outside below your window. You can see me."

"Which window?" she asks. There is only one window in her room, and I wonder how I will coax her to move in that direction.

"How many windows do you have?"

"Two," she responds.

"Go to both windows."

Her voice starts to sound further away. I am afraid she will put the phone down before moving to the window.

"Take the phone with you!" I yell. "Don't put the phone down!" I can hear her shallow breathing as she shuffles towards the window, probably forgetting to use her walker. I can see her fingers moving between the slats of the mini blinds, trying to make an opening. She has forgotten how to open the blinds. I imagine her struggling, trying to hold the phone in one hand while trying to push the slats apart with the other. I wave furiously from the parking lot below, flailing my arms through the air, hoping she can see me. I throw her kisses, willing them to float up towards the person I imagine is standing on the other side of the blinds. I also make another motion with my arms, a virtual hug, as I embrace the empty air in front of me.

"What am I doing?" I ask her, wondering if she can see me.

"She is throwing kisses," Mom says.

"Yes, Gail is throwing kisses and sending hugs too," I tell her.

In the background I hear someone enter her room. I can hear the entire conversation. "I have a cup of coffee for you. What are you doing?" someone asks.

"I am looking out the window," Mom responds.

"What are you looking at?"

"Tell her you are waving at your daughter," I yell into my phone.

Mom's response is quick. "I am waving at your daughter."

I don't bother to correct her grammar. I can hear a rustling and then see the care aide as she opens the blinds so my mother can see me.

"Oh, I see you!" Mom says excitedly.

I throw more kisses and wrap my arms around my body. "I am sending hugs too. I miss you."

She sounds more animated now as she repeats, "I see you!"

"I love you," she adds.

I feel the tightness in my chest release a little. Seeing her makes me feel better. I think she knows it's me on the phone and I hope she knows it's me in the parking lot below.

"I love you," I tell her as my eyes fill with tears that I am glad she can't see.

"I love you too," she says.

I begin our good-bye ritual, the one that always seems to make leaving a little easier. This is my mini mental exam for her. As long as she can remember the rhyme, I know she is still here with me.

"See you later alligator," I say, wishing I could see her eyes.

"See you soon, baboon," she responds.

"After a while, crocodile," I say, and then laugh.

There is a pause. "I don't remember what comes next," she always says.

"You know what I mean, jellybean," I respond.

And then she laughs, too.

ABANDONED

BY LINDA JONES

I was thirty and leaving a man I thought I would marry, but who did not, it turned out, want to marry me. He was strumming a guitar, swinging slowly in a hammock on our leafy balcony as I packed my suitcase and said good-bye. I moved back to my parents' house, had to move back, in fact. My mother had packed her own suitcase and left my father.

Dad couldn't live on his own, needing both a walker and a wheelchair to move around. My youngest sister was away at university so that left me and my other sister, Deborah, to work out what to do. Deb was twenty-five then and coming back to Ottawa for a new job. I remember there was never a discussion about not taking care of Dad. That Deb and I could move home, at that particular time, makes me wonder if Mom hadn't bolted, so much as carefully calculated her exit.

Caring for Dad was like a bulldozer that pushed almost everything else aside. After our workday, Deb or I would warm up a dinner of

frozen fish sticks or packaged meat pies or canned stew. Then, once the dishes were done, we would sit at the worn kitchen table and scribble out a list while Dad waited impatiently for one of us to take him for a drive. This daily list was really a circle, no beginning and no end, of what needed to be done and who would do it: Dad's medical appointments, coordinating homecare, the pharmacy, grocery shopping, cooking, cleaning, laundry. Start again.

There was no room on the list for what I needed, namely time alone to cry and to mend my suffering heart. So I cried in the bathroom, sitting on the edge of the tub, a cool washcloth in my hand. I cried while driving to work, in the parking lot of the grocery store, in my sleep. And I ran, every evening, after Dad was in bed, pulling on an old T-shirt and running shorts, lacing up my worn blue and yellow Adidas on the stoop, the gritty concrete biting into the back of my legs. The nights were cool and sometimes there were stars. I would wind a path through the curving, suburban streets, the soft sound of my shoes on the tarmac, heart pounding but steady and strong.

One morning, a few weeks after Deb and I moved in, I overslept and woke to the clump and rattle of Dad's walker as he made his way to the bathroom. From downstairs, I heard running water, the rattle of cutlery, the beep of the microwave. The scent of toast and coffee told me I was very late. I dressed quickly and went to help Dad.

Every day I was learning more about what he could do and what he couldn't: shirts, yes, if they didn't have buttons; socks and shoes, no. I cradled his thin, blue-veined foot in one hand and struggled to slip a sock over his heel with the other, my eye on the clock. "Dad, we really need to get moving."

He was tangled in his T-shirt, his arm emerging from where his head should be. "This is as fast as I go, honey," he said, smiling just a little, his eyes rheumy.

Helping him get downstairs was a two-person job. He gripped the railing with one hand and placed the flat of the other on the opposite wall. He had done this so many times there was now a ghost-like trail of grey handprints the length of that wall, like a faded primitive cave painting. Deb went down in front of him, and I was behind, watching carefully to see that the heel of his slippers cleared each step. She had laid out his breakfast: two soft boiled eggs, brown toast with a thin coating of jam, canned fruit salad, and a mug of instant coffee which he took with milk and Sweet'n Low. His many pills, organized into a large yellow plastic pill box for the week, were set on the table with a glass of water.

But his newspapers hadn't come. Dad read two every morning, the national and the local, front to back, spread across the kitchen table. By the time Deb and I left for work, he would be deep into them, a second cup of coffee at his elbow. So I skipped breakfast and drove to the convenience store. When I returned, Deb was grim-faced, tiny blue, pink and white pills covered the kitchen floor like confetti. A brown puddle of coffee was spreading across the red-checked plastic tablecloth and dripping onto the floor. Deb picked up the pills, I wiped the table and made another coffee for Dad. We were almost, almost out the door when the phone rang. It was the homecare agency, saying they couldn't find a worker to come that day.

I placed the phone back in its cradle, then dialed my boss and said I wouldn't be coming in. I drove Deb to work, went grocery shopping, visited the pharmacy and drove by my old apartment.

I didn't realize it then, but my mother's leaving must have been the blow Dad was always expecting, always afraid of. When he was ten, he was placed in an orphanage. Both of his adoptive parents had died within six months of each other. Typhoid or pneumonia or some other disease of the poor and the crowded. In the story, the relatives come to the home after the funeral. They divide up the furniture and household

items but no one wants to take my father. So he stands unnoticed in the middle of the only home he has ever known, a small thin boy, confused at the loss of both parents, waiting to be claimed.

He asked us about Mom constantly, called her family in England looking for news, wrote her countless letters asking her to return, "Darling, can't you even send a postcard, please?" Maybe Dad cried in his sleep, too.

On his good days, he could be sweet, telling Deb and me, "You guys are the best!" And occasionally there were flashes of his old humour. One evening, I was rushed and distracted, trying to get dinner ready. Dad was diabetic and needed balanced meals on time. The meat pies I eventually served were still frozen in the middle, each successive bite getting colder and harder. But Dad didn't miss a beat, "Delicious, hon. Thank you. Could I get a sharper knife though?" He demanded meat-pie-flavoured ice cream on our next drive.

One hot August afternoon, Deb was out and I was heading to a BBQ hosted by the parents of a friend. Dad sat in the darkened living room watching TV, the curtains drawn against the sun, a fan moving the air around, but not really cooling it. I stood in the doorway, bag and car keys in hand. He looked up at me and then away to the TV. "I'm off now, Dad. Back in time for dinner, ok?"

"Ok, bye," he said, his voice clipped, not meeting my eyes.

I waited, willing him to look at me, to make it easier for me to go. But he didn't. Maybe he couldn't. There was just the fuzzy noise from the TV and the click of the fan. Outside the air rose in shimmering waves from the concrete parking lot. I threw my bag in the car, started the engine, turned up the radio and left.

The BBQ was happening at an enormous home with an impossibly blue pool in the backyard. The host, wearing a sailor's cap and a loud

Hawaiian shirt, waved me over as I came in and held me in bear hug, shouting, "Look who's here!" A long wooden table on a shaded part of the deck was crowded with salads, baskets of fresh bakery buns, bowls of pickles and olives, chips and salsa. Two metal coolers filled with ice and drinks sweated on another table and music played from a boombox. The air hummed with talk and laughter, the occasional scream or shout as someone got pushed into the pool.

I grabbed a drink and felt a slight easing in my chest, the shifting of a weight. Some friends came over, one flung an arm around my shoulder, asking, "How *are* you? How is everything at home?"

"Good, good. We're making it work," I probably answered. Maybe I changed the subject then or asked someone else a question. Or maybe I put the drink down, exclaiming over the heat of the day and jumped in the pool.

* * *

When I got home, hours later, I sat in the car for a few minutes before going in. My hair was still damp and cool against my neck. I wore the smell of chlorine and coconut oil, and sensed the beginnings of a sunburn on my shoulders. One song played on the radio, then another. When I did go in, the sun was slanting through the window and the air in the living room was still, the fan off. Dad was in his wheelchair, close to the TV. The remote had probably stopped working again and he needed to be close enough to change the channels. He was sunk into his chair.

I sat down beside him, determined to be cheerful and full of news about my afternoon, hoping this might carry us through the moment to dinner and then an evening drive.

But he didn't wait to hear my news, didn't want to hear it. "Couldn't you have taken me with you?" he said in a rush.

The question hung in the still air and I fumbled for something to say. Maybe I could have, I thought. The hosts were kind people who knew my situation. But I didn't ask them. Dad's afternoon unfolded before me, the long hours alone in the hot room, only the TV for company, waiting for someone to come home. Maybe he had tried to reach my mother and failed again. Maybe he wasn't feeling well. He almost never felt well now. I had no true answer I could say out loud, that I didn't want him there.

We had dinner. I hope I made him something he really liked and looked the other way when he had two helpings of dessert. Maybe we took a drive along the river that summer evening.

In the end, Deb and I didn't abandon Dad, at least this is what I tell myself, what other people would tell me. But it felt that way then and it still does. A few weeks after that drive, on another mild summer evening, Deb and I told him he needed to move to a nursing home, that a bed had become available. We sat on the stoop, watching some children play quietly at the next house. I can't remember what we said. I had prepared something, had tried to think through what we would do, what we would say if he flat-out refused to go. But he didn't. He stayed quiet and still, looking out at the children, mottled hands on the arms of the wheelchair.

ABOUT EDNA

BY JOY CRYSDALE

The last time I saw Aunt Edna, she was sitting in an iron-framed hospital bed, the kind you see in infirmary scenes in old movies. I was twelve and wearing my confirmation dress, one made specially for the service in which I had become a member of the church. My parents said seeing me in it would cheer up Aunt Edna. The dress was indeed beautiful. Made by a seamstress, it was white eyelet lace overlaying a sky-blue satin fabric. Wearing it, I felt sanctified.

I didn't understand what was wrong with Aunt Edna and wasn't told, but she was in her seventies and it didn't seem abnormal for an old person to be sick. I had heard my mother on the phone, telling someone about the problem in a vague way. She sounded exasperated when she said that Edna's husband, Bob, "had the patience of Job." What he had the patience of Job for, I had no idea.

We went for our visit after church. Acutely aware of my purpose, I led the way into Aunt Edna's room, shy yet proud in my white lace

and blue. But as soon as she saw me, Edna burst into tears. "Oh," she said. "You look so lovely." My parents whisked me out to the hall where I stood by myself, horrified that the thing I had done, that was supposed to help her, had made her cry. Those weren't tears of pride and love seeing me dressed up for a new stage in my life. I could tell. I knew her weeping was a kind of hopelessness at her separation from all that was lovely in life and the world.

A separation she would soon make complete.

* * *

Today, I have more objects in my house that belonged to Edna than I have memories of her. She and Bob had no children, so, as her great niece, I was left her single diamond engagement ring, which I have moved from drawer to drawer over the years because all I can think of when I see it is how she died. I have her good dishes, the set that belonged to her mother, white bone china with a single gold ring on the outer edge of each plate and bowl that I only use for special occasions. I also have what was once called a hope chest that belonged to her. It sits in the bay window of my bedroom and is the storage place for off-season clothes.

When I was a child, I didn't quite understand how or why Aunt Edna and her husband, Uncle Bob, were in our lives. In essence, they were my paternal grandparents. They helped raise my father after his mother, Edna's sister, died when Dad was a toddler. His father was cut off from Dad for reasons no one explained and to this day no one understands. He also died when Dad was young. Dad lived with Edna and Bob until he married.

Now, more than 50 years after Edna's death, I find myself wanting to know more about her and feeling frustrated that there is almost nothing to find. In sorting through family papers and mementoes, I am

astounded by how little physical evidence there is about her. Searching my own memories, I am dumbfounded by how little is there as well.

What I do have are photographs that show Edna was a plain woman, her short hair in pin curls, her dresses either all in black or in dull patterns, buttoned up to the neck with small collars. She is wearing one in a photo at Niagara Falls, flanked by my brother John, about twelve, and me, about six. Somewhat drab, a shirt-like style above her waist, a fuller skirt below, it seems a dress designed to be ordinary.

Family Christmas dinners are also recorded. It being the late 50s, all pictures are in black and white. In each, Edna looks straight at the camera, her lips thinly drawn. I can't tell if she is trying to smile or if that drawing back is all she can manage. But another photograph from some years before stands out. Edna has her head thrown back, laughing with abandon, my two-year-old blonde self at her feet. What happened to cause the laugh, something I don't remember Edna ever doing, and when that abandon turned to strain, are just some of the many unknowns.

Not long after the visit to the hospital in my confirmation dress, I was taken out of class and told the principal needed to talk to me. In his office, I was gently told to sit down. He came out from behind his desk, sat down opposite me, and told me in kind tones that my Aunt Edna had died. I'm not sure why the task was assigned to him - perhaps it was too chaotic at home and my mother couldn't do the usual drive to pick me up from school.

Much later my parents told me Aunt Edna had been in hospital for depression, had had electric shock treatment, been released, went home, lay down on their couch, took enough pills to be sure to kill herself, and died. When she had been let out from what I assume now was the psychiatric ward where we had made that visit to her, she told her husband, "I know what I'm going to do when I get home." Something he and my parents didn't understand—until after.

Perhaps it was, at least in part, the depression that kept us from knowing Edna. It is a horrible cage that keeps a person separate, trapped in a grey, lonely darkness. In knowing so little of her, what her childhood was like, why and how she met and married Bob, whether she ever had a paid job—anything tangible at all—Edna's death is the most concrete thing we have. That is not right. Who wants to be remembered just for their death?

I have only two distinct memories of her. One is that hospital visit. The other is the time as a small girl when I was with her in her kitchen. I had always sensed a sternness in Edna that made me a little afraid of her. But as I sat on her kitchen chair, I watched, mesmerized, as she peeled an apple for me. She went from top to bottom around the fruit with a sharp knife, in one fluid motion, creating a single intact curlicue of peel. When she finished, with a kind of "ta-da!" look on her face, we shared one of those telepathic moments that can pass between an adult and a child. I knew she was delighted at my delight at what she'd done.

And that is all. By the time Edna died, although she and Uncle Bob were a regular presence in our lives, they had become a relatively insignificant one. When I was younger, we used to visit them in their tiny white stucco four-room house, about a 15-minute drive from our home. Although it faced a big highway, their property had a rural feel, with large pines and willows, and sometimes we'd picnic on the lawn outside. They had a cherry tree I loved to climb, and whose fruit was sweet, unlike our sour cherry tree at home.

But my family of four became six when I was nine years old and my parents took in my foster brother and sister. With our getting older, and everyone's life busier (especially my mother's) and that many more of us, we didn't go to Aunt Edna and Uncle Bob's much anymore. They continued to come to us for Sunday dinners and the

like. But they were fading into the background as elderly people often do in family life. Noise and activity ebb and flow around them as they sit on the sidelines.

When Edna died, I had no particular reaction that I remember, and no sense of loss. When I found out later that she had committed suicide, I fixated on the couch she had died on. I remembered its scratchy feel and the sound of the highway from a time I slept there overnight when I was small.

I assume I was shocked she had taken her own life, but I asked no questions. In contrast to my generation's way of telling and talking about most things about ourselves, it was my parents' and their parents' way not to, especially about unpleasant or shameful matters. I assume that was the reason I didn't ask for more information, though I am usually an insatiably curious person. Or perhaps, Edna just didn't seem important enough.

I know from my father—a consummate storyteller—that Uncle Bob made his way through every book in his local library reading alphabetically. That he gave up his job in the Depression because someone else needed it more. That normally a patient man, he lost his temper when my father brought home a Christmas tree too tall for the house, and he hacked the top off, making it ugly and devastating my father, who had been so proud of it.

But the only story my father told me about Edna from his childhood was that he hated her porridge and got into trouble for throwing it out the window into the snow.

Few memories, almost no stories. Human brains are wired for stories. We need them to grasp the world. We need them to grasp and know a person. I don't know why Edna ended up on the scrapheap of not being known, with no stories. Shame, or a dislike my father thought it was improper to reveal, or perhaps an apathy about her as she became

more of a burden in her older age, given her depression. Edna died when she was seventy-four.

My brother John and I are all that is left of our family of six now, and after we are gone, there will be no one who remembers Edna. I started writing about her in my late sixties, the age Edna was when I knew her as a child. An age at which I too feel myself fading and becoming less significant, less important to the world around me and facing the reality of my own death in a way I never imagined. I wonder what will be known of me after I die? Like Edna, I am childless. Children can, at least for a time, keep memories of a parent alive. But even then—let's face it—the memories of those of us who are not famous will fade. We will be forgotten. When we are gone, we are, indeed, eventually gone.

Perhaps my wanting to record the little I have of Edna is a kick against that, for her sake, and my own, and for others. On the bookshelves in my den, I have photos of people who came to me through family routes, some of them from Bob and Edna's house. I have no idea who they are. But I put their pictures on my shelf as a tribute to their unknown lives.

To them and to Edna, I am saying, 'don't worry, I've got this, for now, anyway. While I can, I will honour you.'

BIRTH CONTROL

BY ANNA-MARIE LARSEN

In small towns, who you're related to and how much money you have and any trouble you get into is what makes people good or bad. That's why when someone asks, *Who are your people?* they're really asking if you're good or bad.

Bad girls are bad for one of two reasons. They're bad because of who their people are, so in a way they have no choice. Things might get better for a bad girl though. For instance, a bad girl might get a job at the Stedman's store on weekends. If she shows up on time and doesn't complain when she sweeps up mud clots that drop like bad news from farmers' boots, she might get extra hours during the rush at Christmas and Mother's Day. Let's say the manager decides to take a chance on her. He trains her to run the cash register. Then he says to someone at the Rotary Club pancake breakfast that *She's very good at making exact change*, that he *Never worries her till will be short.* The next thing you know people are saying to each other, *Well now.*

Despite everything, that little girl's really making something of herself.
That's when you notice people thinking she shows promise even if she
comes from bad people.

The other reason girls are bad is because of things that happen to
them that wouldn't, couldn't happen to a good girl. For instance, on
the first day of seventh grade this girl named Suzanne was sitting two
desks in front of me. I told my mother Suzanne was in my class, that
she must have failed because she should have been in eighth grade.
My mother said, *Didn't Suzanne win that poetry contest two years
back? What a talent.* She said, *Someone interfered with Suzanne* in
the same pinched voice she uses when she pries open Tupperware
containers and says, *Those noodles are a day old and a dollar short.* She
said Suzanne won't make it through until June. That's how I knew
Suzanne was a bad girl now. Suzanne didn't come back to school
after Thanksgiving. She probably didn't miss it. No one talked to
her anyway. She ate lunch alone. The rest of us knew better than to
speak to bad girls.

It's easy to tell who the good girls are. They get their homework in
on time and their hair is always combed. Good girls have sandwiches
with luncheon meat and iceberg lettuce instead of always with peanut
butter. Nice things happen to good girls, too, like getting picked to walk
across the stage in the spotlight at the end of the Christmas pageant to
hand Mrs. Chisholm a dozen red roses. Everyone knows Mrs. Chisholm
wasn't good enough to be a concert pianist, so she married the pharma-
cist instead. She volunteers every year to accompany the junior high
kids while they murder Christmas carols and make everyone wish it
really was a silent night. Haha.

Good girls get asked to babysit for good families. Good families
are easy to spot because they can afford cable television and matching
sofa-loveseat sets. They have moms who say, *Help yourself* and then nod

at a bag of cookies on the kitchen counter. A good family might decide to take a chance and have a bad girl babysit. They might say, *Let's see how she works out.* If you ask me, it's fine to be paid to watch cable TV and eat cookies from a store.

It doesn't matter if a dad is from a good family or a bad one because the dads are probably drunk when they drive you home. They might get a little handsy then, but it's nothing you can't handle if you're smart. Dads might say, *Just gonna check to see if this is closed.* Then they reach across you to pull at the handle of the car door and brush their arm against your breasts, which are so new you feel a little surprised when you look down and see them. Or dads act like something they said is so hilarious they have to slap your thigh, but then they leave their hand there. The next thing you know they've pressed a whole hand into the space between your thighs right at the top and out again so fast you only have time to hold your breath. You can't say anything about it because they'll say you got it wrong, that you misunderstood what happened. Or they'll say, *Can't take a joke, eh?* like the problem is that you have no sense of humour. Or they might call you touchy which is backwards thinking if you ask me because if anyone's touchy it's them. Haha.

I learned to be smarter than the dads. For instance, in winter I wear a thick parka that stops at my knees. It makes it difficult to grab hold of me. Crossing my left leg over my right leg makes it harder for their fingers to poke around my private parts. And there's an upside. When dads get handsy they can be counted on to add a couple of dollars to what is owed. They say, *Thanks so much. We'll call you again.* Some dads wait in the driveway until you get inside your front door. This is nice because it shows they think about your safety. Other dads let you out in front of your house then roar off before you even have time to leap the ditch your Uncle Steve calls a poor man's moat.

My favorite babysitting jobs are summer ones. When a mom calls, I say, *It's nice out. I'll bike over.* Then the mom will think I'm a good, considerate girl because her husband won't have to waste gas driving me. I won't have to worry about what to do if a dad gets handsy when I'm wearing shorts and a shirt.

I let myself out the back door after the kids fall asleep. The sky is grey then, not black, like night is shy to show up. Satellites tack across the airspace. Strawberry plants and marigolds and fresh mown grass mix sometimes as one smell, sometimes you get them by themselves. It depends on what the wind is doing. I sit on the steps and take cookies from the bag. I twist them to split them in two. I lick the icing. I slide sweet hard biscuits into my mouth and break them into shards.

Like I said, people sure act like they know everything about you. But this is something they don't know about me. One day I was in my bedroom when I got this big urge to see my dolls again. So I got them out. I'll be honest. I felt like I was doing something wrong because for sure seventh grade is pretty old to be playing with dolls. I didn't make up stories for them to act out. I mean, I tried but I couldn't think of a good story, so after a little while I gave up. Then this thing happened. Not a thing, I guess. A thought. It showed up real sudden and I was a little startled by it, like when you're really into a book and it surprises you when someone speaks, so you jump a little. Like that. The thought said, *If you get pregnant, you're not getting out of here.* Just like that. After that I sat for a while on the floor with all those dolls and wondered about why that thought showed up. Then I took each doll and dressed it in a very nice outfit. I made sure they were wearing shoes and I combed their hair. I whispered their names, real sweet and soft and all that. I cried some. Then I laid them back in their box and closed it up.

Sitting on the steps is very good but it's not the best part of summer babysitting. The best part is another thing no one knows. On the way home, I ride through the yellow pools streetlights spill on the asphalt roads. I pump hard so my bike will go fast. I stand on my pedals. I spread my arms wide and I balance. My hair is wild like a comet's tail. I want to shout, *Look at me.*

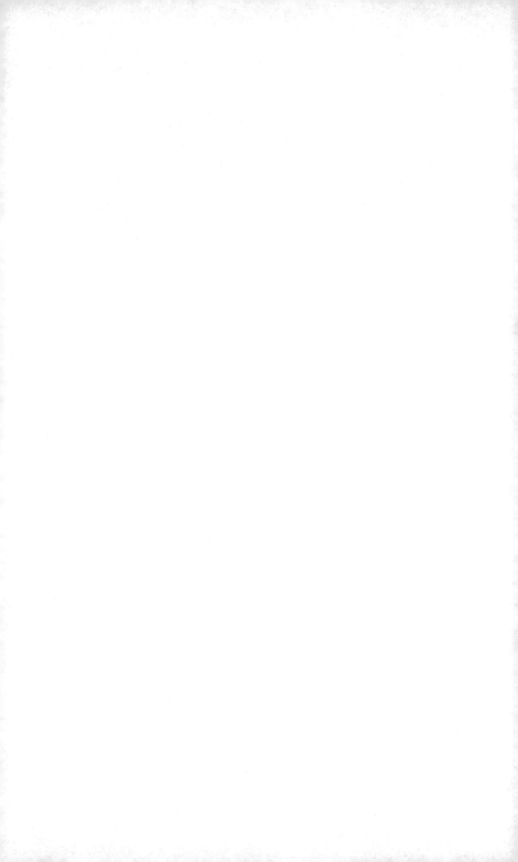

DEAR ME

BY RUTH SCRIVEN

Dear Me,

This is a letter to you, the girl I used to be.

We're not quite strangers, you and I. Although you don't know me, I have known you your whole life. Since you are only four, not quite yet old enough to read, I'm going to sit beside you and just let our hearts read these words together.

I can see you, wrapped in your favourite flannel-lined patchwork quilt as you gaze over the ocean waves as far as your eyes can see. I know your thoughts are a million miles away, locked deep down where you're hoping no one can find them. Your right eye is squinting ever so slightly while your mind whirls like a pinwheel, trying to decipher and decode whether or not you can trust me.

I want to help you to feel safe by letting you know you're not alone. That's why I am writing to you after all these years. Yet, I also know that it's not that simple for you.

It wasn't always this difficult for you to decide who was safe and who wasn't. Like all children, we were taught to trust adults who are there to help take care of us. We were also taught to obey adults.

Little one, I saw you hang your head just now, staring at your hands as they pick anxiously at the worn cuffs of your soft yellow jacket. You may be hoping the curtain of long blonde hair that is now covering your face will also cover the shame and fear in your gray-green eyes. That's something you couldn't hide from me, even if we were here on a moonless night. I know all too well how ashamed you feel. Your mind is also stuck on what I've said about who is safe, who isn't, and about obeying adults.

That's why I'm here. There are some things you need to know.

I see you hesitantly lifting your head. Your bare feet are kicking nervously just below the frayed edges of your jean overalls.

You feel trapped just now, don't you? Too afraid to speak, yet desperate to be heard.

Your mind is reeling, wondering if I know.

Part of you is hoping that I do, because if I know, then you won't have to find the words that are too big for you. You know, the words that get stuck in your throat and make it hard for you to breathe? That's because the words you need to use are words you don't yet know, so you're left only with things that feel impossible to describe.

The biggest part of you, though, is absolutely terrified. Terrified that if I know, then the secret is out, and she will die, leaving you here alone with him. That's why you made that pact with her, remember? You made her promise that neither of you would die before the other, that you'd go to heaven at the same time. So right now, you're wondering what that means for you...if anyone finds out and she dies, does that mean you will die too?

So why don't we start there, you and I? First, though, I see you're shivering. Here, do you want me to pick you up so you can sit in my lap just like you do with Mama? You can even play with my necklace. You seem surprised that I know so much about you. Don't forget, I know that's what you always do because that's what I've always done too. It's where we both feel the safest, when we're closest to Mama.

Speaking of Mama, I want you to know that you don't have to worry. She is safe, I promise you. It's OK for us to talk about your secret, it can't hurt her now. And although it will be a long, long time before you feel safe too, I'm here with you until you do.

Sometimes, there are things we don't like doing, but we need to do them. Chores, for example, like picking up our toys, or cleaning the toilet. Are there things you don't like to do? Yes?

Right now, the first thing that comes to mind is your secret. To you, it's kind of like a chore you hate to do, and yet it feels different somehow, doesn't it? When you do chores, like cleaning your room, does it just annoy you? Or does it hurt you, scare you, and make you very uncomfortable? Exactly. Chores are just annoying, kind of in the same way that eating cooked carrots is annoying.

What he's doing is not like a chore at all, little one. That's not why you don't like it. Your secret isn't even something you are doing. It's something he's doing to you.

You're holding your breath right now; I know because your body is tense and rigid. That always happens to me too. Sometimes it helps to take a moment to just remember how to breathe. Want to try that?

Close your eyes. It's ok, I'm here with you. Breathe in. Breathe out. What do you feel? I noticed the warmth of the sweet salt air around us. Did you feel the warm wind on your face? Yes? Me too. This time, let's focus on what we can smell. Breathe in. Breathe out.

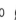

Did you notice the smell of the sun-baked seaweed next to us? Ok, one more time, but now let's listen while we breathe. Breathe in. Breathe out. The sound of the waves feels very soothing, doesn't it? Yes, I knew it would.

Hey, I see you peeking up at me with one eye. It's OK, you can open your eyes if you'd like. We're ready to talk some more.

I know what you're thinking – me too. I wish we were talking about anything else but this. This is important, though, trust me.

That secret you've been protecting? It's not a secret, love. It's something else.

When he does things to you every day that no one else is allowed to see? When he puts parts of his body inside of yours in ways that hurt you and scare you? That's *not* what a secret is.

When he tells you that if anyone finds out, your mother will get hurt? That's *also not* what a secret is.

Do you want to know the *real* secret? I see you nodding your head quietly, so I will tell you.

What he's doing is terrible, and he's the one who is bad for hurting you this way. You are not the one who is bad. You have nothing to be ashamed of. The shame isn't yours to carry.

Not only is what he is doing wrong, but he's also lying to you.

You see, secrets can be good things, like not telling your Mama what you made for her so that she'll be surprised on Mother's Day. Or being super quiet when you're playing hide and seek so that your friends won't know where you're hiding until the game is done. Those? Those are good secrets.

I know you're so confused right now. You've been taught that it's strangers you should worry about, not the people you know. You've also been taught that you're not allowed to say no to him; he's your

father. You just want to be a good girl, so that he'll be proud of you like your Mama is proud of you. It feels safer that way, but only kind of.

You've seen what he is like when he loses his temper or gets mad. He scares you, and you don't want him to be mad at you.

You've seen how violent he can be.

You know how much he keeps hurting your body. So much so, that your mind and body both shut themselves off when the pain gets to be too much.

I know the panic you feel after he leaves your room, trying to clean yourself up and making sure you're ok. It takes so much effort for you to pretend that everything is fine so that no one will know how afraid or hurt you are.

You'll do anything to stay out of trouble, because life is already really scary and bad for you, and you don't need it to get worse.

I don't blame you. That's why we kept the secret for so long. We were both scared of him—scared silent.

You know what, though? I have another real secret for you. The reason he threatened you is because *he's* the one who will get in trouble if you tell.

Not Mama.

Not you.

Him. Your father is the only one who will get in trouble.

It won't even be your fault if he gets in trouble. It will be his fault.

Want to know something else? Your mother won't die if you tell. He just told you that to protect himself.

He should have been protecting us all along. That's what good fathers do.

It's ok to cry, love. I know how much your mind is racing right now. Sometimes, the truth can feel really heavy. I felt so overwhelmed when I was your age too because no one could explain all this to me.

No one could explain it, because like you, I was afraid to tell anyone the secret.

If you don't tell, no one will know you need help, and you'll still be in danger. Yet when you build up enough courage to tell, not everyone will know how to help, and you'll still be in danger.

What I can't tell you right now is how many years it will take for you to feel safe. Knowing what I know, I wish I could pick you up right now, and run far, far away from all of this with you, but I can't. I can only walk by your side and help you through it.

I'm so sorry that life feels as though it's crushing you. At your age, you should be thinking about things like riding your bike, snuggling with Mama, exploring the beach and getting ready for kindergarten. Instead, you are torn between what feels like two worlds—the one where you have to figure out how to pretend that everything is fine, and the one where you have to figure out why everything isn't.

You don't have to feel alone anymore. I'll help you bring those two worlds together so that you won't feel so utterly broken and torn all the time.

It pains me that we had to wait so long to have this talk. It's something you've needed for as long as I can remember, but I had to find help first. Just like no one could explain it to you until I came along, no one could help me either until now. I know how awful it feels to not understand something, or much worse, not to be understood. Knowing you felt that way, as soon as I could find some help, I came back so that we could talk.

From now on, I'll be right by your side, and I'll explain things along the way.

It's going to be a long, long journey, but you will make it through. You know how I know that?

Because you are the most courageous girl I've ever known.

GUNS, GOLD, AND GRACE: ELDER CARE IN THE NEW PANDEMONIUM

BY KAREN BESS

What was said to the rose that made it open
was said to me here in my chest. Rumi

Caring for those with dementia presents a major challenge to our faith...
It tests whether we can love lavishly without expecting anything in return...
Jane Thibault, *No Act of Love Is Ever Wasted*

Cicadas are a mythical, maniacal superfamily of insects; the operatic antics of their love life saturates my senses for weeks. For seventeen years underground, they are driven by the dream of sunshine, while still mere nymphs nursing at tree roots. Yes, the ground warms in late

spring, and they are called to come up and throw off their burial cloaks. For a few weeks they take over the town in a jubilee of light, flight, loud love songs, late-in-life sex . . . then, soon, they die.

Here, perched near the Ohio River in central Kentucky, I'm back in my own childhood stomping grounds, where I once ran wild among majestic beech trees on the river bluffs. Billions in the Magicicada chorus of Brood X are slowly warming up to a solar-powered crescendo on this bright morning. Such energizing and mesmerizing mantras, like having a monastery of Tibetan tenors in the neighborhood! I adore their bumbling flight paths, their faithful courtship at all costs, those big red eyes ablaze against a robust black body, the fearless way they climb on and cling to my finger. My elder indoor cat is poised, pawing the air, as they careen into my window screens. My aging dad just down the road sits staring and forlorn at his bird feeders, his winged buddies off to a better buffet. Gazing up from my garden late in the afternoon, I see that the big maple has a swirling halo, as cicadas swarm on golden, see-through wings. One brief burst of bug life devoted to incantation and copulation.

Backing down the drive last week, I heard my father's shouts, then screams, piercing the cicadas' deafening din, as if his skin was being ripped from his body. He was in full-blown "fight" mode—impressive for a near ninety-year-old man who is losing everything. I was fleeing with his prized possessions: three pistols he'd long kept in the master bedroom. The loaded 357 Magnum nested on the pillow beside him. At this point in Dad's dementia, he could barely walk or maneuver a spoon. Around-the-clock in-home care was starting, and all valuables had to go; my newest nightmare was that he'd maim or kill a caregiver. In the driveway, Dad's grief and powerlessness turned to raw rage like a heat-seeking missile aimed at me—his eldest, dutiful daughter and power of attorney, aka "The Warden."

Isolated in his home and guarded to the hilt for a year on the heels of losing his wife of sixty-four years, Covid finally caught him in January, quickening his weakness and confusion. Just like with Mom, we've been scrambling on the slippery downslope of dementia. In her last months, Mom was hell-bent on going "Home." She walked out of the house with her purse one day, and a neighbor found her, unharmed but fallen in the yard beside the road. Mom morphed into an angel-child in the weeks before she died. A life-long smoker, she finally forgot to smoke, to our great relief and amazement. She shrank smaller and smaller into an ethereal version of herself, with a huge grin of sweet welcome for everyone and everything. Our relationship transformed into one of playful abandon and uproarious laughter, until the last hours when she fought for every breath in my and my sister's arms.

My father's father, an Army medic in World War I, died a few weeks before Dad was born and was rarely spoken of again. The youngest of four boys, Dad often remembers hunting with his brothers and cousins, always adding, "I was the dog." A hard-hat Navy diver, he got a bad case of the bends, contributing to his life-long anxiety. Always driven, he was a self-made business success, becoming a top dog in the electrical supply industry. Once I asked if he had any regrets; after a brief pause, he said, "I wish I'd spent more time with family." Yet he couldn't stop going to the office until three years ago. He rarely spent much money, clinging more to the *idea* of any wealth he'd managed to accrue. It is painful, watching him sift through the safety deposit box at the bank, again and again, like Smaug the Dragon keeping an eye on his pile of gold. As he weakens and softens, in the body and mind, I look for openings in his armor.

Like a moth to the flame, my fascination with families of all kinds is a never-ending mystery. As a family therapist, I've felt the searing heat of misguided passion and lethal memories; I've also loved clients back

to life through a shocking clarity I can only call Grace. As a daughter, granddaughter, and niece to five military men, I inherited a fierce fighting spirit as chief protector of my peoples. Cradled in the fearsome times of both world wars and the Great Depression, they knew strife and poverty beyond my imagination. My father's big extended family stuck together, had each other's backs. Before my parents' debilitating declines, I teamed up with a cousin to serve as first responder, medical overseer, trustee, eulogist, and listening ear for an aunt and uncle in their nineties and their special-needs daughter—orphaned in her sixties after their deaths. In her last days, my prophet-cousin Deb kept declaring: "I don't believe in death! I don't believe in death! I don't believe in death!"

I link arms with legions of Boomer-caregivers stretched impossibly thin, our parents living longer than ever before. We wander lost in the labyrinths of a frightening, fractured medical milieu, making ourselves old and sick, isolated and intimate with death in a death-denying culture. All made much worse since Covid. I am blessed with resources to hire help. I bow down, my whole body to the ground, in honor of the unsung, unseen and unpaid family caregivers in this country.

Dancing elders through death is a supreme spiritual practice. Every prayer or peak experience in my lifetime, every confession and shard of humility, every mentor or tyrant—living or dead—who came to me in daylight or dreamland built me up for this trip. Each and every warrior pose, every resentment nipped in the bud, the countless hours communing with dirt have prepared me for this ancestral apprenticeship. Brother Thomas Merton nailed it: "In my ruin is my fortune!"

When Dad went ballistic over the guns, I was curiously calm while backing away. I was not in fight or flight mode, but something subtly, yet clearly, snapped. In therapy speak or Twelve-Step talk we might call it a key moment of differentiation or detachment. Lately, I sense

a new brand of serenity, a wonderful whisper of inner freedom that is hard to describe. Though I've rarely used or thought about this word, it came floating up: *Dignity*. One dictionary defines it as "the personal quality of being worthy of honor and esteem." The late Congressman John Lewis discovered the word anew as a college student while in jail after a lunch-counter demonstration in Nashville: "I had never had that much dignity before. It was something I learned, the sense of independence that comes to a free person."

In a sense, standing in that firing line, between my father's laser longing and his guns, destroyed me. A knotted, crusty cord in my guts came undone. Perhaps that part in me that, *just like him*, is chained to busy-ness as a defense, a thick exoskeleton to deflect going deeper. My earliest memory of being close to Dad is of our dancing; I'm standing on his shoes as a child. It went to rough-housing and boxing as a teen. Sometimes it hurt, sometimes a lot. He's always cringed at being hugged by any of us, even the grandkids. Somehow, intimacy went underground. We never talked much in our family, but Mom and I found our way to a tender bond after she got sober thirty years ago. Our family "love language" turned into *service*, meaning relentless work, especially as our parents' aging hampered their ability to get things done. Each family develops a signature nervous system over time; ours was stitched tightly with high expectations and scant rewards, binding and hiding ugly wounds that leaked through the fabric, like a living shroud embroidered with *No Problem!* For a long time that harness helped me excel in ever-higher education, to focus on meaningful work; it killed any attempts at starting my own family. Perhaps only the extreme sport of death-dancing during the pandemic—the bodies piling higher, the grief tamped down, down, down—could break me, empty me out sufficiently, to slip out of the damn straitjacket.

It's been a long time coming, this letting go, like a beech tree holding tight its tough coppery leaves until late winter. From this threshold, I will keep turning over Dad's daily care to trusted others— remarkable caregivers who also helped my mom, like surrogate family. I will seek and find ways to be a daughter *first*, to be more palpably present to joy and pain, invite some sabbath into the last turn with my father. What might it look like to "love lavishly," to dance with an old dragon?

* * *

The cicada chorus is fading; it is easier to hear the nuance, their pulsing, breath-like rhythms as dusk descends. Countless nymph casings and dead adults are piled up, crunch-crunch on sidewalks; how many millions missed their chance at the dance? Eggs are tucked inside tree tips; in a while they'll drop into the ground. What on earth do they *do* down there for so long? They're wired for oneness, and so are we. But they have the simplicity and solidarity to wait, to follow their dream and stick together, no matter what.

Never underestimate an insect, not even one. Just now on my front porch, I heard the click-click distress call of a cicada and found one caught in a cobweb, flapping its wings and going nowhere. With my broom I gently released her, unharmed; she sat quietly on my hand for a while and then rejoined her destiny. Suddenly I knew on some cellular level that I, too, am safely unfurling my wings in an unswept corner of my psyche, shedding the worn-out caregiver skin, handing in my jailhouse keys. A late-bloomer, emerging as Elder in my own right. I can trust now, standing in the fullness of my experience. I am more than enough, worthy of honor indeed, as my wings stretch and shine in the sun. May they carry me to new treetops, new vistas—did I mention I'm engaged?

In seventeen years, when the new cicadas return, I'll be my momma's age when she died; now there's an inspiring and sobering fact! May the 2038 Cicada Soundtrack of Love find me singing, cavorting and ever-trusting the firepower, flowering, here in my Heart.

"No coward soul is mine,
No trembler in the world's storm-troubled sphere
I see Heaven's glories shine,
And Faith shines equal,
arming me from fear."

Emily Dickinson

128 BULWER STREET

BY DANIELA PACIENTE

We move house a lot. Mamma says it's because we always end up living next door to bad people. We've been in this house for almost four months now, and I really like it. Maybe we can stay in this one. Maybe these neighbours won't be bad. It has a garage, even though we don't have a car, and it's bigger than the last house. There's a huge tree in the back yard, and I climb it to look over at the kids next door and watch them play. I'm not allowed to go to their house. "You never know what sort of people they might be," says Mamma.

Sometimes, Ruth comes to my house. Mamma doesn't like it, but every now and then she lets her, if I cry and beg.

"You will be the death of me, *mi vuoi ammazzare*. Do you want to kill me?" she asks.

There are three kids next door. Ruth is two years older than me; she's ten, and I wish I looked like her. She has long blonde hair put up in a ponytail with pretty ribbons. I wear a hat, because Mamma took me to

the barber shop to get all my hair shaved off when I got nits. The kids at school laugh and call me Baldilocks.

"That's what you have to do," Mamma had said when I begged her not to. "You have to shave it all off and then rub your head with kerosene. It's the only way they will go away. Now stop crying, you want to kill me?" Mamma always talks about dying. She won't even buy a new coat now it is winter because she says she'll be dead soon, so it's not worth it.

I wish I had a little sister like Ruth does who would let me push her around in the stroller, and a brother like hers who I could play with. I don't play with my brother; he's seventeen, and anyway, I don't think he likes me very much. Mamma says that when I was little, he'd get in a bad mood if she picked me up when I cried, so she didn't. She said that was a good thing to do because when he was angry, he would hurt me. Sometimes, he pretended to leave for school, and then he would run back inside to see if she had picked me up. Mamma always worried about that. She would go outside to make sure he had gone first.

My brother has a girlfriend. I know he has one because I found a photo of her in his dresser, under the brown paper that lines the drawers. Sometimes, at night, when Mamma falls asleep on the couch and my brother is out, I go into his bedroom and tidy his drawers. I like doing that, but he never notices. Sometimes, I even leave notes on his bed: *I love you Joe*, but I find them screwed up in the bin. She looks pretty, his girlfriend. I like her hair. It's long and wavy. On the back of the photo she's written, *To Joe, my love always, Jean xxx*.

I thought that one day he might bring his girlfriend home, but he never does. "A girl who stays out at night with boys is no good," I'd hear Mamma say.

Mamma sleeps a lot. She falls asleep after dinner, when Papa has left for work, sitting upright on the couch, her head nodding, mouth

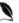

open, spit dribbling down her chin, drying like snail tracks on the path after it's been raining. Then she jerks awake and looks across at me, to where I'm sitting on the orange-patterned armchair she got from the second-hand shop, wishing she'd wake up and talk to me. Wishing she'd take me to clean my teeth, or put me to bed and tell me a story.

"I don't know why I'm so tired," she mumbles, half asleep, half awake. "It's all the work I have to do in this house. I don't know where I find the strength to go on."

Then her head nods again, her mouth slackens and she breathes loud and heavy in time to the ticking of the gold clock on the mantelpiece. That clock was the only thing Mamma had left to remind her of Italy.

"Your father sold everything I had to come to this godforsaken country," Mamma would say.

It's Papa's fault that she's always sad and crying. And it's my fault too because I never do anything to help her. I try, but she doesn't let me.

One Sunday, Ruth knocks on the door and asks if she can play. I look at Mamma beseechingly. Mamma sighs, "I suppose so," and jerks her head for Ruth to come in, casting me a disapproving look, her mouth set in a hard line. We go into my bedroom. Ruth brought her doll and we build a castle, using wooden building blocks to make the walls and coloured tissues for the carpet.

"I'll close the door so we can use this bit of floor in the game." Ruth points to the area in front of the doorway.

I'm afraid to say no. I hear Mamma sweeping the passage. "Alright," I mumble.

The broom knocks against the closed door as she sweeps the linoleum floor. I know I shouldn't have the door closed. I know why Mamma is sweeping. I know she will be angry. She says that doors should always

be kept open because nothing good ever happens behind closed doors. But Ruth will think it's a silly rule and I want her to be my friend. So I don't say anything.

We continue with the game. Our dolls have become princesses, my bedroom a castle. The footsteps that come, stop, and then go again outside the door interrupt my imagination. I can't concentrate on the game; I just pretend at make-believe. Ruth doesn't notice.

"Time to come home now, Ruthie," her mother calls from over the fence.

"I have to go," says Ruth, and collects her doll.

We move the shoe box that moments ago had been a throne from in front of the door so she can open it.

"Bye, Mirella. Thanks for having me over, Mrs Rocco," calls Ruth as she goes out the front door. Mamma is silent.

Next morning, I get up and go into the kitchen, the swept linoleum floor in the hallway cold under my bare feet. Last night's dishes are piled up in and around the sink, drips of cold water from the tap sliding over the dried-up grease on the plates. A cockroach strolls across the food scraps left on the table.

"Where are you, Mamma?" I know where she'll be, but I hope that just maybe this morning she'll be up. Maybe she'll be outside hanging out the washing, maybe she'll be talking to Mrs. Simpson over the fence. She might make friends with her, then Mamma might go over and have a cup of tea, like the other mothers did, and she'd see that Mrs. Simpson is nice. Then she'd let me play at Ruth's house.

The back door that leads into the kitchen swings open. Papa is home from work and he'll be angry again. Papa is well rugged up because it's cold outside and he rides a push-bike to and from his shift at the bakery. I want to help him take his coat off.

"I can manage." He shrugs me off. "Where's your mother?"

His eyes slide over the messy kitchen; he sniffs the air, locating the offensive food odours. His tongue rolls up towards his palate like it always does when he is mad. I can see the purple and red veins as he bites down hard on it. He breathes noisily through his nose and storms to the bedroom. My heart is thumping.

"What the hell do you do with your time, woman?" he bellows. "Do I have to come home to this every goddamn morning? The place stinks! Every room's a mess. I can never find anything. Do you spend all your time in bed?"

"*O Dio, Dio,* I'm sick," comes a whine from under the covers.

My father stomps across to her side of the bed and tears the bedclothes from her curled-up body. "Then get the doctor to give you something other than those damn pills you swallow that turn you into a zombie. I'm sick too—sick and tired of you. I don't know what makes me stay. I swear, someday..."

I creep up the passage, my heart pounding. My throat is so dry I can't swallow. Please God, make him stop. I can see Mamma through the crack in the door. She looks so small and she's crying.

"It's not that sort of sick! I'm sick because I've come to the end. *Sono finita.* I can't take any more." Mamma is sitting up now. I can see her pulling nervously at the strips of white material that she puts in each night to curl her hair. Mamma always says that she's even been cursed with straight hair that hangs limp and does nothing for her.

"All night I've been up, and the noise has been worse than ever. Do you know what she's been doing to me...that, that bitch next door?" Mamma's voice has become a high-pitched whine. "Slamming doors, hitting the wall with a hammer..." She takes a deep breath, she's shaking all over. "I haven't said anything before, you never believe me. I've

tried to bear it alone. Ah, but she's *furba*, so crafty. She lets me get to sleep for half an hour and then she makes things crash to the floor to wake me up. It's been going on for weeks; my heart can't take any more! My nerves are broken." Mamma is wringing her hands; her face is screwed up and ugly. My father puts his hands in his pockets, his shoulders slump.

"Nila..." he begins.

"It's alright for you," she's screaming now. "You work all night—she knows that! That's why she does it then. She's trying to drive me crazy."

"Mirella. Come in here!" My father's voice is resigned.

My feet feel like lead as I push the door open and stand in the doorway.

"Have you been up all night too? Where's your brother? Did he hear any of this? Was he kept awake too?"

"That's right, make me out a liar again," Mamma screeches. "Their rooms are on the other side of the house. That witch only does it to me. And as for *Giuseppe*, or Joe as he's called in this hellhole of a country you've brought us to...nothing would wake him. He's out half the night, doing God only knows what with that...that *putana*. Does he care that his mother is here, half dead with worry?"

I don't want to stay there in the doorway watching Mamma cry. Can't he make her happy? I always try to, but I don't know how. Slowly, I take two steps backwards. Mamma shoots me an accusing glare. "And that daughter of hers is just as bad! She's in on it too! Don't think I didn't hear her yesterday. I heard the two of you whispering, "She's this, she's that! She's trying to turn you against me! She's a wicked girl! She made you close your door, didn't she?"

"Mamma, no, it's not true...I, we, we weren't talking about you. We truly weren't...we were playing, just playing..."

Mamma wasn't listening.

That afternoon, when I come home from school, the newspaper is open on the kitchen table at the 'To Rent' section. I hear Mamma in the bedroom, opening and closing drawers, dragging suitcases from the top of the wardrobe. We're moving again.

PO-PO'S COOKING

BY ALISON FEUERWERKER

I am twelve years old. My grandmother is living with us. I call her Po-po, which means maternal grandmother in both Cantonese and Mandarin. Tiny and frail in a striped housedress over stockings and slippers, hair dyed black and permed into a Brillo-pad of curls, she is dwarfed by our kitchen: the white Formica countertops halfway up her chest, the window over the sink barely at eye level. To reach into the cupboards, and to reach the back burners of the stove, she wheels a rolling step-stool from place to place across the linoleum floor.

Amid cluttered surfaces—counters covered with magazines, newspapers, phone numbers on scraps of paper, my unfinished homework, appliances missing their insides, potted plants gasping for life—Po-po hurries to start supper before my mother gets home from work. At the university across town, my mother dismisses her English Literature class, flings books and lecture notes into her overstuffed briefcase, bolts from the classroom, races down the hall and out the door, and runs the

half-block to her car. Her goal: to reach home before my grandmother begins to cook. Last night Po-po recreated a salad she had sampled at the Kmart lunch counter: soggy lettuce leaves and chunks of ham coated with mayonnaise.

My mother is held up in traffic. As she opens the front door, her nose is accosted by the smell of canned cream of celery soup mixed with soy sauce.

"Mother, you don't have to cook supper!"

"It's no trouble," says my grandmother. "I discovered a new dish at Mrs. Yeh's house, and—"

"I planned to cook chicken. I took it out of the freezer this morning."

"You know Al doesn't like chicken. I don't see why you always serve food your husband doesn't like. In Hangzhou I always made sure the cook prepared your father's favourite dishes. He looked forward to coming home for supper."

"We don't have a cook, and I get tired of everyone's special needs. Al doesn't like chicken, Alison thinks she's a vegetarian, Paul doesn't eat anything with more than two ingredients—"

"That's why I'm cooking! To help you!"

My mother gives up. Her ears are assaulted from two directions: my brother pounding out a Bach minuet on the piano in one room, me attacking a Kreutzer study on the violin in another. She goes upstairs to her office.

My father arrives home from a history department faculty meeting just in time for supper. We eat at exactly 6:30 so he can watch the news at the same time. With the Vietnam War casualty statistics droning in the background, the five of us take our places around the wobbly Formica table, set with my grandmother's favourite red and yellow plastic dishes, which she loves because plastic was not available when

she was growing up in China. My brother picks up a pair of pink plastic chopsticks and sorts the food on his plate into piles by colour, remarking, "I don't like this stuff."

"When your mother was your age," Po-po says, "she never complained about food. It was during the Japanese invasion and sometimes all we had was plain rice. She ate everything cheerfully, no matter what."

"I like plain rice," my brother says.

My father rummages in the kitchen for cheese and crackers and brings them back to the table. My brother reaches for some. I pour soy sauce over my rice and eat it with chopsticks, ignoring the overdone meat and soggy vegetables. My mother, eating heroically, attempts to start a conversation: "Al, do you know who's speaking at the faculty lunch tomorrow?"

"Why does it matter?" my father says. "None of them know anything."

"I don't think that's true."

"Your colleagues are lightweights. Kindergarten teachers, that's what they should be."

"That isn't fair. "

"Your father and I never argued at the table," says Po-po.

"I don't think he has a right to insult the people in my department. At least they're normal human beings—"

"They all need psychiatric help," says my father.

"Isn't this a good dish!" exclaims Po-po. "Mrs. Yeh made it the other day. The recipe is from *Reader's Digest*."

We clear the table. My brother goes back to the piano, my grandmother to her room upstairs. It is my turn to do the dishes. As I stand at the sink, I hear my brother's practicing in one ear and my parents' conversation in the other.

"Why do you let your mother cook?"

"I can't stop her! I don't get home from work in time."

"Everything your mother cooks is disgusting."

"I suppose you think your mother was better! Stuffed cabbage and gefilte fish. At least my mother's cooking is low in cholesterol."

"That's irrelevant."

"I don't see what's irrelevant about it. You have to watch your cholesterol and lose weight."

"I do not have to lose weight. You're exaggerating."

"No I'm not! Statistically, you're overweight for your height."

"Why are you always nagging Al about his weight?" My grandmother has entered the fray. "He looks fine. You shouldn't criticize your husband."

"I'm not criticizing, I'm concerned about his health."

"When your father and I were first married in China, his mother told me he had a weak stomach and that it was my job to take care of him. Even though we had a cook, I always supervised in the kitchen. 'Make sure to prepare Mr. Mei's favourite dishes,' I always said."

"We do not live in China," says my mother. "And we do not have a cook. You didn't have one either, after those first few months. Most of the time you were running away from the war."

"You only want to remember the bad things!" says my grandmother.

"Also," my mother continues, "Al is an adult. He can take care of himself."

"You'll ruin your marriage with an attitude like that! Women today have no respect for their husbands."

My mother turns to my father, who is immersed in the *New York Times*. "Say something!"

"Fairbanks' book on the Chinese Revolution has been published," he says and turns a page.

"Talk about irrelevant!" my mother exclaims.

"Just because you are an intellectual lightweight—"

"My daughter is not an intellectual lightweight! She got top marks in her class every year!" My grandmother is shouting now.

"Only because the Chinese school system was inferior—"

"That is not true!" Scraping and rinsing dishes, I dream of growing up and getting out, of someday living a calm and dignified life.

* * *

A few years later, my grandmother decides to strike out on her own. My mother and I pack the red and yellow plates, the pink chopsticks. We help her settle into a small apartment on the other side of town. Po-po writes memoirs from her life in China and submits them to the local paper. They are published in a regular column, fulfilling her lifelong dream of being a writer. After three more years, she moves from Michigan to Massachusetts to be nearer her other daughter, her son, and their families.

The year my own daughter is born, my mother and I visit my grandmother. In her two-room apartment, in a seniors' complex on a quiet, tree-lined street, red and yellow plastic dishes spill out of the cupboards. The kitchen table, piled with papers, is Po-po's writing desk. She is still writing memoirs and has published her autobiography. She is losing some eyesight and hearing but none of her self-assurance.

"I'll make supper tonight," she says.

"Oh mother, we'll order take-out food."

"Those Chinese take-out places don't know what they're doing. Besides, I want to try out a recipe my neighbour downstairs found in the *TV Guide*."

We sit down to a meal of soggy vegetables and overcooked meat, featuring both soy sauce and cream-of-celery soup, familiar and somehow dear to me.

The doorbell rings. It is the downstairs neighbour, coming to say hello. My mother hands her a camera and asks her to take a picture of "four generations of Mei women": my grandmother, my mother, me, and my daughter.

* * *

Both my grandmother and my mother are no longer with us these many years later. I often look at the picture. Po-po, tiny and frail in her house dress, holds my infant daughter on her lap. My mother, awkward in front of a camera, smiles too brightly, her face showing signs of strain. And I, looking so much like my mother, am gazing in wonder at the sight of my daughter on the lap of her great-grandmother. I keep the picture as a reminder of what connects us through the generations. For we all inherited not only my grandmother's stubborn streak, but also her capacity to love fiercely and to defend those she loves against all reason. And her ability to colour memory and make stories of our lives.

TAKE A PHOTO BEFORE I LEAVE YOU

BY AMY MACRAE

Click.

I'm caught again. My friend beams at me from behind her phone. "You two are so adorable!" she coos.

I push my daughter on the swing, throw my head back and laugh, mouth open, conscious that I am being watched.

Click.

Another photo, another option, another angle. In case our eyes are closed, perhaps, or in case the pictures don't capture the candidness of the moment in just the right way.

A mother with her daughter.

A loving mother having fun with her daughter.

I know all the reasons these photos are being taken. I know what these photos will be used for and where they will be displayed. But I laugh and smile nevertheless.

My husband, Garreth, rarely used to take photos of me. Usually, he was preoccupied with a beautiful view, intricate architecture or an exotic car sighting. I'd often poke fun at him for the ridiculous things he would photograph.

"Why the heck do you want a photo of that license plate?" I'd moan. "Are you really going to look at that later?"

"Yeah," he'd reply defensively, scrolling through thousands of little squares in his camera roll. Gargantuan sandwich, limited edition sneakers, lewd graffiti, blurry shot of a deer in the front yard. My default was always to limit photos. I felt it took something away from the experience, seeing life through the lens of a phone. Saving the experience for later, somehow negating the ability to remain in the moment. But Garreth always wanted to collect photos, to store little jokes and bits of beauty to perk himself up on a later day. A grid of colours to scroll through, validating his experiences, making up for his lacklustre memory.

So, when he started collecting images of me, I noticed.

"Is he worried he'll forget me?" I wondered. "Or maybe scared that she will?"

They tell me that I'm different, that I'm stronger, that I'll beat this, that I'll still be here. But they collect photos for when I'm not.

This terrible thing happened to him, too. This unbearable loss changed the course of Garreth's life as a child. But this time, he has advance notice. He can make preparations. He can store things for later.

But it isn't just my husband, it's everyone: my parents, my sister, my brother, my friends. I watch them, my senses tuned for the moment

when, in the midst of a purely joyful moment, something dawns—their realization that time is limited, but more pressingly, that I am limited—and they reach for their phone.

Mother reading books with daughter in bed.

Happy family collecting berries at the farm.

Two best friends out for a sushi dinner.

Click.

Their actions, their use of the camera, betray their words. They reassure hope at every turn, spew out platitudes and attempt to comfort me with, "No one really knows for sure." They tell me that I'm different, that I'm stronger, that I'll beat this, that I'll still be here. But they collect photos for when I'm not.

After my cancer diagnosis, I started smiling with my teeth. I can't explain why, I just did. Maybe I had been too self-conscious about how I looked before. Maybe it had felt too awkward and revealing, too forward, putting all those teeth out there, opening myself up for the world to see, to judge, to dissect. "Look at her goofy smile," I'd imagine them thinking. "And that kale stuck in her upper incisor." So, I'd always kept my mouth closed and turned up the corners of my lips, tucked together and tidy.

But after cancer, once it seemed like everything in my life had been ripped open, when everything I had tried so hard to keep neat and contained came spewing out, I smiled with my teeth. I couldn't control my health, I couldn't control my life, so why control my self-image.

I am thirty-four years old and I've had a rare, incurable form of ovarian cancer for two years. The doctors say I might have one to two years remaining. My daughter, Evie, is four. My daughter, my whole world, not yet old enough to form memories she will carry

into adulthood. Will I live long enough to become someone to her, a memory to link along with photographs and stories she's told?

When Evie looks back at all these photos after I'm gone, I wonder who she will see. I wonder what she thinks about the way I look. I know there was another me, a pre-cancer me, but she doesn't. I feel guilt that for most of her conscious life the mom she has known is a sick one. The mom Evie knows spends most of the day in bed while she is cared for by her grandparents. The mom Evie knows ingests more pills than food, can't lift her up and spends most of her life in pyjamas. For me, this is a bad phase. A dark chapter near the end of the book. But for Evie, this is all there ever was.

I wonder if Evie will know that her mom was a stylish dresser who loved fashion and used it as a language to express herself. Perhaps one day my mom will tell Evie about how I begged to wear a suit to prom. Or maybe Garreth will tell Evie about the brown knee-high fur covered boots I wore on our first date. I don't know why this is important, but it is. Because cancer has taken so much from me, has changed me. But there was someone before her. A girl who had her own style and dressed to the beat of her own drum. Who wasn't afraid to stand out and who was beautiful in a way that she isn't now.

Will I live long enough to become someone to her, a memory to link along with photographs and stories she's told?

Recent images of me could be described as "unfortunate"—and that's generous. I am either bald or with hair in stages of sprouting, awkward in length and texture. Despite my love of fashion, clothes are now purchased for comfort as well as their ability to be quickly stripped off, due to the hot flashes surgical menopause has induced. Multiple surgeries have left my stomach bloated and distended, and a lack of physical activity and courses of steroids through chemotherapy have

left my body soft. A lack of energy and perpetual naps mean make-up is no longer practical or applied.

However, rather than blocking the camera, rather than hiding or putting up verbal opposition, I allow the image to be taken. In fact, I even smile.

When life is coming up to the final bend, perhaps fashion, beauty and self-image should be the last things one should consider. Dressing well seems like vanity, a frivolousness I can't afford to care about at this point in my life. Yet I have cared. And still do.

Click.

It's Evie's fourth birthday party and all of her friends and our family are in attendance. Garreth and I kneel down to align our heads with Evie's, who is poised to inhale her cake. As I bend forward, a curly brown ringlet pops forward and I tuck it back behind my ear.

Made in India, most likely. I read somewhere that that's where most human hair comes from these days. I imagine some poor woman cultivating hair down to her buttocks, sweating under the hot sun for years, only to have it chopped off and shipped across the ocean. My wig is stunning, brunette with shades of blonde and warm tones of honey. It's also excruciatingly hot and itchy and cost as much as a used car. It lives on a stand in my bedroom, tucked away in the corner. There if I need it or want it, which I normally don't.

This particular day, Evie's birthday, it sat ignored while we dressed for the party. Evie and I wore coordinating butterfly print outfits. I despise butterflies, but as far as four-year-old birthday themes go, I suppose she could have done much worse, and I've never been one to shy away from a theme. I made up my face for the occasion and felt a sense of pride as our family of three gathered in the entryway to put on our shoes. Evie looked around to assess the situation.

"Mama, aren't you going to put on your wig?" Evie asked.

I said, no, I wasn't, not today, and that we were ready to go.

"But Mama, don't show my friends your bald head. Put on your wig!"

Garreth went on the defensive. "Evie, Mama looks fine," he pressed.

But I was already dashing down the hallway. "It's fine, it's fine, it's fine, it's fine," was my breathless, calming chant as I wrestled to balance the cap of the wig over my head.

"It's fine," to placate Garreth. "It's fine," to reassure Evie. "It's fine, it's fine, it's fine," to convince myself, my mantra when the life I was living seemed too heavy to bear.

Two hours later, there we were, the three of us, grinning as four candles flickered in the centre of a butterfly-shaped cake. Me, with long, wavy hair, the picture of health. Recorded, eternalized, captured.

But not saved.

AMY AWARD BIOS

SHORTLISTED AUTHORS OF THE 2021 CONTEST:

Native to Louisville, Kentucky, **KAREN BESS** and her people have been dwelling along and near the Ohio River since the mid-1800s. A once-upon-a-time farm wife, martial artist, dam fighter, and landscape designer, she is now a trauma-informed family therapist and veteran of elder care. Becoming an elder herself, she's exploring memoir as mentor. Her mother wrote for the Louisville & Nashville Railroad magazine. Karen has been published in Family Therapy Magazine and is writing a book entitled *Guts, Gravity & Grace: The Power of Polyvagal Bodywork for Curing Chaos.*

JOY CRYSDALE wrote two books of educational biography for young readers, *Fearless Female Journalists* and *Courageous Women Rebels* before venturing into the field of memoir writing. She began by taking writing courses after completing her career as an award-winning television journalist and professor of journalism at Humber College in Toronto. Memoir writing is an almost wholly different craft than journalism, and when she is not beating her head against her keyboard, she thoroughly enjoys it. Sometimes. She thanks all those at *Memoir Writing Ink.* for the opportunity to share her story *About Edna* with a wider public.

HILARY FAIR's work has been published in *Change Seven*, was short-listed for The Creative Nonfiction Society and *The Humber Literary Review* non-fiction prizes, as well as for the *Women on Writing* CNF Contest. She has worked for *The Walrus Magazine* and taught short fiction in the Sarah Selecky Writing School, and she became a potter while studying Spiritual Care and Psychotherapy. Hilary is a writer and psychotherapist living, to her ongoing surprise, back in her hometown of Stratford, Ontario. She identifies now as a re-emerging emerging writer.

ALISON FEUERWERKER is a community musician, activist, and traveller: a mix of Chinese heritage from her mother, Eastern European Jewish heritage from her father, a left-liberal and eccentric American childhood, early adult years living in intentional community, and a more recent year of living and working in Tanzania. She is based in Ontario, Canada. A short essay Alison wrote as an exercise for Memoir Writing Ink will appear in an anthology titled Nonwhite and Woman: 131 micro-essays about being in the world, to be published in September 2022 by Woodhall Press.

KARIN JONES's essays have appeared in *The New York Times*, *The Times of London*, *Huff Post* and *Entropy* magazine, among others. She practiced medicine for eighteen years as a Physician Assistant before returning to school for a nursing degree. Karin works at her dining room

table on memoirs about menopause and motherhood in Bellingham, Washington, and writes the monthly 'Savvy Love' column for the UK's *Erotic Review Magazine*.

LINDA JONES has scribbled in journals and written essays and short stories throughout her life. Most of these are carefully stacked in a plastic bin in her basement. But a few years ago, retirement and an empty nest meant more time to write and to submit to contests and publications. She lives, hikes and writes (*almost* every morning) in Chelsea, Quebec.

The first story **ANNA-MARIE LARSEN** finished won the Dorothy Schumacher Award. The second one made the shortlist for the Peter Hinchcliffe Short Fiction Award. *Birth Control* is her third story. Because it was also shortlisted, she now agrees that, yeah, the writing thing is going well. She lives in Waterloo, Ontario, and is seriously considering finishing other stories.

DANIELA PACIENTE, although never published, has written in one form of another her whole life—mainly journal entries and memoirs. The Amy Award was her first attempt at any competitive scribing. To have been short-listed was a true honour and has spurred her on to keep writing. She lives in Perth, Western Australia, one of the most isolated places in the world, and hopes to get to one of Alison Wearing's writing retreats very soon.

GAIL PURDY started writing two years ago in a memoir writing class offered at the local community center. This last year she participated in *Memoir Writing Ink*, an online course that helped her to find and develop her unique writing voice. Gail lives on the west coast of British Columbia where she enjoys taking long walks in the forest. Physical and mental health are important aspects of her life, along with creating visual art through painting and photography.

Having been silenced for many years, **RUTH SCRIVEN** found her voice by leveraging writing as a way to help others. From her little patch of earth on the Canadian east coast, she spends most evenings cocooned in her writing nook, writing her memoir, *Dear Me*. In between chapters, she can be found in her therapist's office, on the beach with her canine companions, or responding to emails in her head without pressing send.

Alumni of *Memoir Writing Ink*.

JUDGE OF THE 2021 CONTEST:

ANNE BOKMA has been a working journalist for more than thirty years and is the recipient of the 2020 City of Hamilton Arts Award for writing. Her 2019 memoir, *My Year of Living Spiritually: One Woman's Secular Quest for a More Soulful Life* (Douglas & McIntyre), received the nonfiction and Kerry Schooley book prizes in the 2020 Hamilton Literary Awards.

Anne is the founder of the 6-Minute Memoir "speed storytelling for a cause" live storytelling event in Hamilton, Canada. She also runs a 6-Minute Memoir Online Writing Workshop Series, which is designed to help participants select, shape and share a true tale from their lives. She recently launched the 6-Minute Memoir podcast.

ABOUT ALISON WEARING

ALISON WEARING is a Canadian writer, playwright, and performer. Her writing has won a National Magazine Award Gold Medal, been a finalist for the Journey Prize, nominated for the RBC Taylor Prize, shortlisted for the Edna Staebler Award for Creative Nonfiction, and her books have become national bestsellers. Her numerous theatre awards include Best Dramatic Script at New York City's *United Solo*, the largest festival of solo theatre in the world.

Alison's current project, *Memoir Writing Ink.*, is an interactive online program that guides people through the process of transforming personal stories into memoir. In her spare time, Alison is a devoted hiker, yogi, and cultivator of laughter.

ABOUT AMY MACRAE

AMY MARISSA MACRAE (née Ho) was born in Calgary, lived for several years in Toronto (where she met her husband, Garreth) but spent most of her life in Vancouver. Amy was a passionate educator, teaching behavioural special needs kindergarten. Amy was also a tireless, and immensely proud mother, to her 5-year-old daughter, Evie. Amy recently found her voice as a writer and added prose to her repertoire of skills and passions. Amy died on June 1, 2020, at the age of thirty-five. Her story, "Take a Photo Before I Leave You" was shortlisted by the 2020 CBC Nonfiction Prize.

Lightning Source UK Ltd.
Milton Keynes UK
UKHW010721170922
409018UK00001B/241